IMAGES
of America

MILFORD

Pictured is Charles (Chappie) Brewster, a longtime school crossing guard in Milford, with (from left to right) Danny Inderrieden, Linda David, Hal Carter, and Brenda Hoffard standing outside Milford Main Elementary School. (Courtesy of Larry Curless.)

On the cover: Brewster never played hooky from school. He loved his schoolwork, and he was a school crossing guard for the Milford School District for many years. Brewster and his wife lived on Center Street. They had no children of their own, but they were both special people when it came to the town's students. The Milford Parent-Teacher Association honored Brewster for his 34 years of service as a crossing guard at the Milford Elementary School at Main Street and Lila Avenue by installing a bronze plaque at this crossing. The plaque reads, "The Children's Friend, in recognition of loyal service as school crossing guard during the years 1937–1970." "None of the children ever gave me any trouble," Brewster said. (Courtesy of the Greater Milford Area Historical Society.)

IMAGES
of America

MILFORD

Greater Milford Area Historical Society

ARCADIA
PUBLISHING

Published by Arcadia Publishing
Charleston SC, Chicago IL, Portsmouth NH, San Francisco CA

Printed in the United States of America

Library of Congress Catalog Card Number: 2008920508

For all general information contact Arcadia Publishing at:
Telephone 843-853-2070
Fax 843-853-0044
E-mail sales@arcadiapublishing.com
For customer service and orders:
Toll-Free 1-888-313-2665

Visit us on the Internet at www.arcadiapublishing.com

This book is dedicated to the people of the Greater Milford area who have generously shared their photographs and histories with the Greater Milford Area Historical Society. The mission of the society is to collect, preserve, interpret, and promote the history of the Milford area and the Victorian lifestyle. It is our hope that this publication will encourage the preservation of history as it is recorded through photography.

CONTENTS

ACKNOWLEDGMENTS

In 1967, several very wise residents and business people determined that Milford's history needed to be collected and preserved for the future. Among the group were Virginia Critchell, Joyce Snell, Roger Early, and Leonard L. Harding. Using their knowledge of the area, these leaders were able to gather photographs and other historical items to preserve many moments from Milford's past. The photographs are now part of the Leonard L. Harding Jr. Library, which is located in the Promont House Museum in Milford.

While compiling this publication, the Greater Milford Area Historical Society tried to include as many areas of Milford's history as possible, and we sought photographs and information from the community. We realize that many topics of interest may not be included and apologize for not having information about that person or event.

Special thanks need to go to the following persons for their dedication to this publication: Kathy McCurdy, Greater Milford Area Historical Society librarian, led our efforts and did much of the research needed to authenticate photographs and history. The library team of Carol Baer, Diane Breig, and Larry Curless put order into this work. Nancy Storch, Suzanne Pattison Zesch, Virginia Critchell, Gail Laudeman, Joyce Snell, Richard Nordloh, Larry Curless, and Tim Jeffries shared their many photographs, memories, and expertise. Donna Amann, Greater Milford Area Historical Society administrator, served as coordinator.

Please note that some information was located in the following volumes: *Bridge to the Past: A History of Milford, Ohio*, by Greater Milford Area Historical Society; *History of Clermont and Brown Counties, Ohio*, by Byron Williams; *History of Clermont County, Ohio*, by J. L. Rockey and R. J. Bancroft; *Cincinnati, Milford and Loveland Traction Company*, by David McNeil; *Cincinnati and Columbus Traction Company*, by David McNeil; *Descendents of Godfrey Gatch of Baltimore County, Maryland*, by Virginia Gatch Markham; *The Lewis Gatch Family of Ohio*, by Brett Harper; "The Good Old Days," a newspaper column by Chuck Rose (Charles Rosenzweig); Ancestry.com; and the Cincinnati and Hamilton County Public Library.

Unless otherwise indicated, all images are courtesy of Greater Milford Area Historical Society (GMAHS).

INTRODUCTION

In a state of nature the site of Milford and the surrounding country possessed a picturesque beauty to which even the practical pioneer could not be blind. No wonder, then, that it struck with rapture that old Knickerbocker, the quaint and eccentric John Nancarrow, who had it surveyed for him on May 28, 1788 . . . and on it this old Dutch burgomaster intended to found a city that should become the future metropolis of the West.

—From *History of Clermont County, Ohio*, 1880

The city of Milford was founded at the narrows of the Little Miami River, just above the mouth of the East Fork in a small, beautiful valley about 16 miles east of Cincinnati. It was in this valley that nature provided a relatively shallow fording place just above the broad ripples of the river, which made it the main crossing point of most travelers and wagon traffic moving to and from Cincinnati to points east and north of the river.

Like most towns in the early development of the western frontier, Milford owes its existence to the river. It provided nourishment to the inhabitants and the power to support the early commerce and industry that grew up on these banks. The first land owner in the Milford area was John Nancarrow, an eastern land speculator who was caught up in the "Ohio Fever." The first permanent inhabitant of the area was the Reverend Francis McCormick, a veteran of the Revolutionary War and a Methodist minister from Virginia. McCormick exchanged his military warrant for 1,000 acres in 1796. The Reverend Philip Gatch, who later became a delegate to draft the constitution for the new state of Ohio, soon followed with his family and friends from Virginia. He purchased land from McCormick and built his cabin overlooking the East Fork of the Little Miami River. Nancarrow also sold acreage to Gatch, who later sold 120 acres of this parcel to his friend Judge Ambrose Ranson. Ranson then in turn sold 64 acres to John Hageman, a miller who came to the area in 1803, and made arrangements with Gatch to build a gristmill. In 1806, Hageman laid out the town he wanted to call Hageman's Mills into 46 lots. However, in a *Liberty Hall and Cincinnati Mercury* newspaper advertisement dated February 3, 1806, lots were offered for sale in the town of "Milford," and so it remains.

While Milford has grown beyond its original parcel, its heritage continues to be defined by those who have occupied the plots of land that Hageman envisioned to be a modern and vibrant midwestern city. Religion played an important part in the development of Milford, as evidenced by the early founders' deep beliefs in individual freedom and dignity. Milford was home to the first Methodist class in the Northwest Territory in 1797, with its first church being constructed in

1818. In 1854, St. Andrew Catholic Church was established, and in 1925, the Jesuits constructed a seminary for religious training. Today Milford's rich religious heritage continues with over 20 churches representing various denominations.

Two of the more notable residents from the Milford area were Dr. Charles Gatch, one of the physicians present at Pres. Abraham Lincoln's assassination on April 14, 1861, and John M. Pattison, the 43rd governor of the State of Ohio.

Business and transportation dominated the activity and growth of the area during the early 1800s. Merchants such as Mathias and John Kugler used the power of the Little Miami River and build mills, tanneries, distilleries, and packinghouses. Local area farm products were then shipped to the growing populations of Cincinnati and beyond. Transportation to move these products began with the stagecoach lines on the Old Anderson Road in 1826 and later on the first rail track through Milford about 1841. One of the notable travelers on the rail system through the area was Gen. George McClelland, who headed up the union training encampment in nearby Camp Dennison. Another was Lincoln, who passed through Milford in 1861 in route to his Washington inauguration. Here Lincoln made a short speech at the Little Miami Railroad depot. To reach points west, it was necessary to cross the Little Miami River. In 1815, the state general assembly approved a bill that enabled the construction of the first covered bridge. This toll bridge was followed by an iron bridge in 1894 and by a steel bridge in 1925. Today a four-lane bridge spans the same area and continues to provide access to points west for the many travelers and residents.

With the growth of commerce and the development of the infrastructure, Milford was poised to enter its Victorian era. Local businessmen began installing gaslights on Milford's main streets in 1870. A town orchestra and a cornet band were organized, adding a local and cultural flavor to village life. The town hall and opera house provided fine music and entertainment for local residents. Private residents, such as the Irwins, who owned an estate known as the Ripples, often engaged in lavish parties, entertaining as many as 400 guests in an evening. William Megrue was a wealthy businessman who made his fortune selling mules, horses, and produce to the Civil War recruitment center at Camp Dennison. Along with several members of his family, Megrue built an Italianate mansion on a promontory off Main Street. This elegant structure was later the home of Pattison.

Education was of extreme importance to the people of Milford. The Milford Academy, Milford Seminary, and Mulberry Seminary were all early efforts to provide a comprehensive education prior to the building of the tax-supported Union School, which opened in 1870. Education today maintains its importance, as can be seen by the school system receiving an excellent rating from the State of Ohio.

The town of Milford and its environs has always been a place where innovation, hard work, and a sense of purpose allowed for individual growth and prosperity. Business and industry have continued to prosper through the early years of the 20th century, as noted in the development of shopping centers and industrial parks. In 1981, Milford became a city and to this day remains the only city in Clermont County. However, there remains an almost spiritual reverence to preserve the integrity of those 46 lots John Hageman laid out in 1806.

One

IN THE BEGINNING

This view of Milford in the 1880s is taken from across the Little Miami River on what is now Route 126. On the Milford side of the river, one can see the covered bridge leading into Milford and the Motsinger and Eveland Funeral Home and Livery. Also the Milford Town Hall and Opera House can be seen on what is now Main Street.

This is a view of Milford from the Hamilton County side of the Little Miami River, showing the covered bridge as it crosses the river into Milford around 1818.

In 1795, the Reverend Francis McCormick (1764–1836), a Revolutionary War veteran, his wife, Rebecca Easton, and family began their long trek from Frederick County, Virginia, to Bourbon County, Kentucky. They remained there for a few months, and in 1796, they traveled north, crossing the Ohio River. They followed the course of the Little Miami River, settling about a mile north of the town now known as Milford, where he had a land grant of 1,000 acres.

In 1811, the Reverend Philip Gatch made a special sorrowful entry in his personal little blue notebook, which he had diligently kept since October 7, 1777: "On the twelfth day of July, 1811, my wife Elizabeth Gatch died after along and heavy affliction . . . I have comfortable reason to hope she had fallen asleep in the Lord, one of the best Wives and Mothers and a nursing Mother of Israel." The next day, her body was buried in the family cemetery, which is now Greenlawn Cemetery. They raised four sons and four daughters: Presocia, born in 1779; Martha, born in 1782; Conduce, born in 1783; Elizabeth, born in 1786; Ruth, born in 1788; Thomas, born in 1791; Philip Jr., born in 1793; and George, born in 1796.

This early-1900s farm scene was typical of the times. It was located near the bottom lands off South Milford Road. (Courtesy of the Laudeman family.)

S.P. ATWOOD LBR.CO.-1869.Located across river near RR Station.

Purchased by Knaul Buckingham and John Hair, Sr., and being advertised as such in 1905.

Chas Nold Saloon

This is the S. P. Atwood Lumber Company in 1869. It was later purchased by Knaul Buckingham and John Hair Sr. and was advertised as such in 1905. Located to the left of the lumberyard is the Charles Nold Saloon, popular with many local residents.

John Hageman constructed the first improvement in waterpower in 1803 when he erected a gristmill above the broad ripples of the Little Miami River. Two small buhrs (millstones) were housed in a rudely built structure covered with wood slabs. He selected a prime location on the south side of Mill Street, where the bottomland fell away, providing an excellent site for waterwheels.

This rock fountain, near the bridge between Scott's Mill and the Millcroft, spouted water from the top. One side was a trough for animals, and the other was cool water for people. The invention of the automobile made watering spots obsolete. One local historian said that it was removed because so many people hit it with their new automobiles.

13

Here are front and back views of the warehouse and distillery built by Daniel McClelland, located at 220 Mill Street. It was purchased in 1828 by Mathias Kugler and his son. They greatly enlarged and improved the mill. The building was used for carding and fulling wool. After a time, this machinery was removed and replaced with milling machinery. The mill was operated successfully by Kugler until his death on January 5, 1868. Following Kugler's ownership, the building passed through many hands and served many purposes. It is still in use today.

The first Methodist class in the Northwest Territory was founded in 1797 in the log cabin home of the Reverend Francis McCormick and his wife, Rebecca. Pioneer worshippers walked many miles through the wilderness to attend its circuit-rider services. As the church rapidly grew, it moved to the Reverend Philip Gatch's larger frame house. In 1808, members erected a chapel on Main Street. In 1818, Milford's first church building was also erected on Main Street. The present sanctuary, seen in the photograph above, was built on property donated by Ambrose Ransom and was consecrated on Christmas day, 1836. The bell tower and Sunday school rooms were added in 1870 to meet the growing needs of the church. Several unidentified members are standing in front of the church. This photograph was taken by O. P. Ashworth of Milford in the late 1800s.

Dedicated on June 18, 1865, the first St. Andrew Catholic Church was located on the corner of Elm and Water Streets. By the late 1870s, a new rectory was built next to the church on "the island." This area was subject to flooding, and on March 5, 1897, floodwaters did great damage to both buildings. In 1913, floods again covered the island, and in 1919, the parish purchased a new rectory at 543 Main Street.

On Sunday afternoon, July 9, 1922, the cornerstone of the new St. Andrew Catholic Church was laid. This event was preceded by a parade through the principal streets of Milford. Over 1,000 people took part as well as a large number of priests and church dignitaries. On June 24, 1923, Archbishop Henry Moeller solemnly dedicated the present church.

In 1890, the Milford Presbyterian Church was organized with 37 charter members, and the first sermon was delivered by the Reverend W. S. Acomb. The cornerstone was laid on July 9, 1904. The history of the church as a separate congregation ended in 1931, when financial difficulties, intensified by the Depression, made it necessary to vote itself out of existence. The church was demolished in 1937.

The Society of Universalists of Milford was organized in 1888 by the Sarah Scott and her sister in their home. Soon outgrowing this space, the cornerstone of the edifice was laid at 102 Mound Street with Masonic ceremonies on July 18, 1891. On Sunday, September 8, 1892, the Universalist was christened St. Paul's. The Reverend W. M. Backus was pastor. In the 1950s, the Universalists gave up their church.

Samuel Thompson, a cooper smith, arrived very early in Milford and built a public house on the site of 39 Water Street. By 1815, Thompson Tavern had grown to be the "best hotel in Milford." This tavern/hotel was later known by several other names, most notably the National Hotel.

Emmanuel Hawn opened Hawn's Public Tavern with his brother Samuel. The structure was built on part of lot number 44 of Hageman's original 46 lots, which is now 313 Main Street. Milford was incorporated by an act of the Ohio General Assembly, passed on January 23, 1836. It was at Hawn's tavern that the first village officers were elected on March 26, 1836. This site is currently occupied by Bishop's Bicycles.

Access to South Milford from the southeast is over the East Fork of the Little Miami River. There have been several bridges erected at this location connecting South Milford Road to what is now Round Bottom Road. This bridge is located just past the Terrace Park Country Club and the new Pattison Elementary School. The first bridge was built in approximately 1872. The photographs shown on this page are of the bridge built in 1902. It was destroyed in May 1915 by a cyclone.

Local residents have long enjoyed relaxing afternoons along the shores of the beautiful Little Miami River. The gentlemen and ladies in these two pictures are properly dressed for this time period, the early 1900s. This well-known spot on the river has provided background for many Milford festivals, activities, and recognized canoeing competitions. It is now designated as the Little Miami National and State Scenic River.

Two

THE TOWN OF MILFORD

The Milford lamplighter's duty was to light streetlamps. Each light consisted of a number two oil lamp in an octagonal glass diamond shaped box mounted high on a post. This 1890s photograph is of Zania Jones. The cart was a red one with two wheels, and the horses were white, making quite a striking picture while performing his tasks. Local resident Magee Adams remembered that Blythe Jones, Zania's grandson, served as a lamp tender when he was a youth, driving a pair of ponies attached to his cart. (Courtesy of the GMAHS, Rinckhoff Collection.)

An eight-classroom union school building was constructed in 1868. This included a high school. The Milford Union School was built on five acres in front of the present Milford Main School. The clay for the bricks, made and fired on the school grounds, was from a nearby hillside. The belfry was added in 1884 when S. P. Atwood and John Iuen donated a bell. The building was demolished in 1913.

This is the Milford Union School class picture from 1902. On the far left is superintendent Prof. C. A. Wilson, and on the far right is teacher Sallie B. Scott. Scott taught in the Milford schools for 37 years until her death in 1921. As an extremely popular teacher, school was cancelled the day of her funeral so that the students could attend.

Milford Town Hall was built in 1889 of native brick and had a slate roof. It was gabled and turreted. When completed, the town hall and opera house was reminiscent of a Rhine castle. The first public use of the hall was for Milford High School's commencement in 1891. It also housed performances by the Milford Opera Club, the Milford Cornet Band, and the Milford Orchestra.

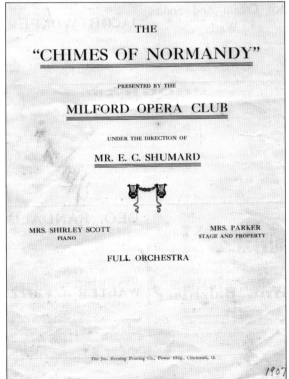

This program, dated 1907, is from the Milford Opera Club whose performances were held in the Milford Town Hall and Opera House, under the direction of E. C. Shumard. The program lists various local merchants, including Booso's Ice Cream Parlor, Scott Brothers Feed Mill and Coal, Milford Hardware, Adams Bakery, and J. A. Lotz Barbershop.

This is an original front view of the John Kugler home, facing Water Street. It later became Dr. Richard C. Belt's home and medical office. For many years, the building was the home of the Millcroft Inn, a very popular and well-known fine dining establishment serving Milford and all of the Greater Cincinnati area. (Courtesy of Larry Curless.)

Plum Savage, Belt's right-hand man, stands in front of Belt's stable. The actual stable later became known as the Stable Inn (a local pub) at the Millcroft Inn.

The Robert Hair property at Garfield and High Streets is one of Milford's old historic homes. At one time, it was a tearoom and was called Rose Lawn. Dollie Spencer (1851–1926) made her home there for many years. She was one of the most widely known women in Clermont County through her social and civic works. She was a founder of the Milford Progress Club, and she was a leader in the Clermont County Federation of Women's Club and Ohio Newspaper Women's Association. She served as a probation officer in Clermont County Probate Court. Her home was often open to Cincinnati working girls for vacations, and her many flowers at Rose Lawn gained national attention when she ran for mayor of Milford in 1921. It was thought she was the first woman in the country to run for mayor. At the time of her death, she was actively promoting a county-wide health education program. (Courtesy of Virginia Critchell.)

In 1895, William Taylor Irwin and his wife, Mary Louise Orr, purchased 88 acres of land above the Little Miami River. The house and all the outbuildings were built of rock and stone from the river. The house became known as the Rock House Lodge and the estate was called the Ripples for the sound of the water flowing over the rock bed.

The Milford Novitiate was founded and opened in 1925 as the sixth Jesuit novitiate in the United States. For a half a century, it served as a Catholic training school as the Sacred Heart Novitiate of the Chicago Province on property called the Ripples. It consisted of sleeping quarters, a chapel, a library, a study hall, and classrooms. The building in the photograph at left was completed in 1927.

The Milford High School girls' basketball team of 1914 was coached by Eva Marie Taggart. Their picture appeared in the first yearbook published for Milford High School. It was called *The Mirror*. The team boasted a record of five wins and six losses. Note the uniform style.

This is the Milford High School football team of 1919. Only three players wore helmets, and they played the game this way too. Typically, practice started on the second day of school. In this picture, note the building in the background is standing where St. Andrew Catholic Church is today and to the right is where Milford Main School is located.

It was on March 26, 1911, that a Bell Telephone Company repair crew posed for a photographer. The team of horses and wagon was from the livery stable at Milford. The driver was Buck Fitzsimmons from Milford. From left to right are Claude Newell, William J. Johns, Mr. Conover, William Everett, Bert Barbrow, and Buck Fitzsimmons.

This picture shows the reunion of the 89th Ohio Volunteer Infantry from Milford in 1913. The picture includes Oliver C. Gatch, who enlisted as a private in the infantry's Company G from his father's farm.

The Milford Cornet Band, founded by Thomas M. Shumard, is seen here in this picture from about 1910. His son E. C. Shumard took over the band in 1903 and began holding concerts on Thursday evenings. They often performed on a moveable platform in various locations. The audience had to find seats where available.

The Grand Army of the Republic (GAR) was founded in 1866 to strengthen the fellowship of those who fought to save the Union, to honor the dead, and to aid the widows, orphans, and wounded. Included in this photograph are Col. Charles L. Greeno, Lt. J. A. Jones, J. B. Wallace, W. L. Fory, H. P. Cook, R. H. Langdale, Colonel McCormick, Master John Gatch, L. N. Gatch, Major Stewart, Rev. G. L. Dart, Rev. J. W. Mason, Judge Jelke, and J. M. Pattison.

Patricia Christy, the narrator for this Welcome Wagon fashion show, is shown on the left. Models from left to right are Janet Dugger, Betty Johns, Ruth Boone, Nadine Wagner, and Marilyn Martin.

This is the Milford High School band in the Milford Fall Festival parade in 1947 led by majorettes Jo Ann Messer and Sue Hohl. This large parade drew 36 float entries. The winners were Homestead Inn, first prize; Rosenzweig Department Store, second prize; and Central Feed and Supply, third prize. (Courtesy of the GMAHS, Rinckhoff Collection.)

The Milford Kiwanis Club was chartered in 1928. This picture is of a Kiwanis dinner honoring the Milford High School basketball team members who were first in the Clermont County League and won the league tournament in March 1939.

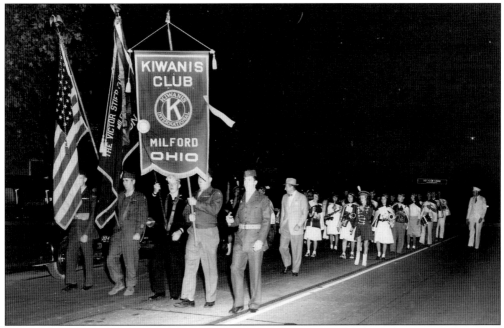

The Victor Steir American Legion Color Guard and Kiwanis Club lead the 1947 Fall Festival parade. The Milford High School band, directed by Dan Koch, follows. Legionnaires in view are Dorsey Holden (second from left), Lewis Wiggins, and Howard Odoms (right). (Courtesy of the GMAHS, Rinckhoff Collection.)

At the time of this picture, this giant bur oak was approximately 750 years old and was located on the John N. Gatch property. On April 29, 1996, a storm brought down the giant *Quercus macrocarpa*, whose trunk was 25 feet around. The wood from the historic tree was made into furniture for the Gatch family home.

Built of native fieldstone between 1820 and 1826 by Judge John Pollock, the Gatch family has occupied this home, known as Arrowhead Farm, since 1850. This is the farm where the above bur oak was located. Gatch family members have owned and lived in this house since its purchase.

Rosa Caplinger worked for the Hodges family at the "castle" on the hill in Milford. She said, "To me, it was the most elegant house I have ever seen." Having studied to become a nurse but not old enough to be certified, she went to work as a nanny to Phoebe Hodges, daughter of Roy and Phoebe Hodges, and as caregiver to Henry Hodges, patriarch of the family and owner of the house.

Local Milford Girl Scouts and Boy Scouts pose in front of Milford Town Hall at 18 Main Street with aluminum materials gathered for the World War II national defense aluminum recycling program.

"School days ahead. Support our new building," and "Let's get a whole ocean full of votes," say the kindergartners and some of their mothers parading in front of the old stone Kugler buildings on the corner of Main and Mill Streets in 1940. The parade was organized in support of a bond issue to add classrooms onto the Milford Main School. The Milford Progress Club pursued the

establishment of a public kindergarten in Milford beginning in the 1930s. Because of the lack of space, the children's classes were held in the town hall. Josephine Harper was the kindergarten teacher in the 1940s.

As written in the *Miami Valley News* on Thursday, September 6, 1956, "Reminiscent of the days when the ball was less live, pitchers not so good, and home runs stood out like diamonds in the dust," pictured is the 1908 Milford baseball team.

In 1938, the organization of the Milford Garden Club celebrated its 10th anniversary. The club provided a means to express the love of gardening. During the early years, the Milford club carried out several civic projects to make the village more attractive, including beautifying the grounds of the public schools and the town hall. They also held fund-raisers, had picnics and luncheons, and entertained guest speakers.

This picture is of an etiquette class at Milford High School in 1949, taught by Virginia Marquette (standing). Pictured at the front table, from left to right, are unidentified, unidentified, Marilyn Berger, Donna Siebert, Frances Riehle, Donald Lawrence, and four unidentified boys; at the back table are Jean Mullin, Ruth Osborne, Virginia Hunt, Frank Roberts, Jim Whittenbarger, Paul Pschesang, Lloyd Berger, and unidentified. (Courtesy of the GMAHS, Rinckhoff Collection.)

Seated is T. Paul Jordon of Milford, chief engineer for WLW Broadcasting in Cincinnati. Seen in the booth reflection behind Jordan is Peter Grant, WLW newscaster and national radio and television personality.

This 1911 photograph shows Alice F. Stewart and many of her friends dressed in hospital attire for a farewell party, as Stewart prepares to leave for nursing school in New York. In 1915, the war in Europe drew the Milford native and New York–trained nurse to a British and French Red Cross emergency hospital in France at the western front. Stewart traveled to New York in 1912 at age 31 to study nursing at Roosevelt Hospital. The former Milford Post Office clerk, Garfield Avenue resident, and oldest daughter of Adeline Stewart and the late William E. Stewart graduated in 1914, the oldest member of her class, as war broke out on the European continent. Stewart traveled to France with a Canadian-born classmate, Mary Watts, arriving in November 1915. Of Americans in World War I, Stewart was among a small number of nurses who saw the war from its earliest years to the November 11, 1918, armistice.

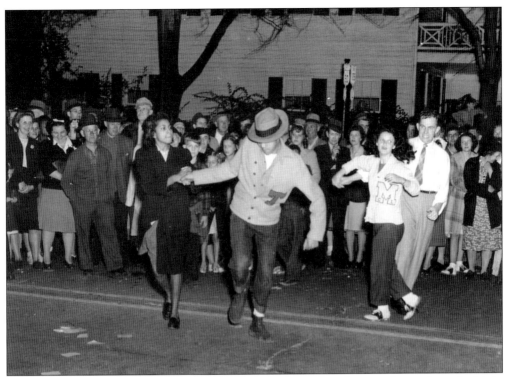

At the annual Fall Festival celebration, a dance contest takes place in the road on the Main Street side of the Millcroft Inn. The finalists in the contest this year were Milford cheerleader Elaine Pierson and Miles Elstun. Note the huge crowd enjoying the competition. (Courtesy of the GMAHS, Rinckhoff Collection.)

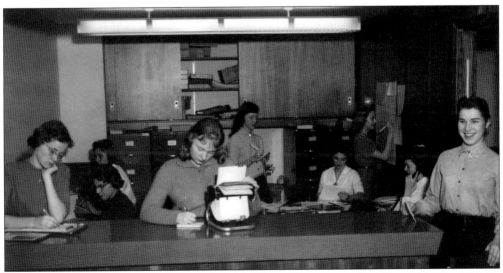

Here are Milford High School students at work in the principal's office of Milford Main, then housing grades kindergarten through 12. Note the state-of-the-art office technology and equipment and the dress code of the day. This photograph was taken in the 1950s.

Here some local boys are just being boys.

A group of Milford High School students gathers outside of the Milford Main building for a photograph around 1910 or 1911.

This team-drawn "sleigh" is traveling down Main Street with its load of happy children from Mrs. Bancroft's Nursery School. The kids, Santa, and the band all seem to be having fun, even without any snow. The photograph was taken around 1947.

Good will day was held by the Milford merchants each week. The winners drawn from the barrel won shopping money to be used at local stores or prizes donated by merchants. In this 1948 photograph, clothing styles, shoes, and automobiles of the times are clearly visible. (Courtesy of the GMAHS, Rinckhoff Collection.)

Sarah B. (Sallie) Scott, a lifetime resident of Milford, was an 1883 graduate of Milford High School. Superintendent S. T. Dial was so impressed with Scott's performance as a student that he asked her to return to Milford Union School as a seventh- and eighth-grade teacher, after studying for a year at normal school. Scott taught in the Milford schools for 37 years until her death in 1921. Several Milford yearbooks have been dedicated to her memory. Below is the plaque that was dedicated in her honor after her death. It remains to this day in the Milford Main School's hallway.

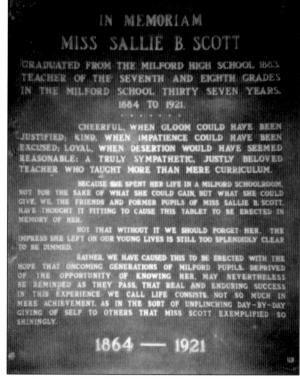

IN MEMORIAM
MISS SALLIE B. SCOTT

GRADUATED FROM THE MILFORD HIGH SCHOOL 1883.
TEACHER OF THE SEVENTH AND EIGHTH GRADES
IN THE MILFORD SCHOOL THIRTY SEVEN YEARS.
1884 TO 1921.

CHEERFUL, WHEN GLOOM COULD HAVE BEEN JUSTIFIED; KIND, WHEN IMPATIENCE COULD HAVE BEEN EXCUSED; LOYAL, WHEN DESERTION WOULD HAVE SEEMED REASONABLE; A TRULY SYMPATHETIC, JUSTLY BELOVED TEACHER WHO TAUGHT MORE THAN MERE CURRICULUM.

BECAUSE SHE SPENT HER LIFE IN A MILFORD SCHOOLROOM, NOT FOR THE SAKE OF WHAT SHE COULD GAIN, BUT WHAT SHE COULD GIVE, WE, THE FRIENDS AND FORMER PUPILS OF MISS SALLIE B. SCOTT, HAVE THOUGHT IT FITTING TO CAUSE THIS TABLET TO BE ERECTED IN MEMORY OF HER.

NOT THAT WITHOUT IT WE SHOULD FORGET HER. THE IMPRESS SHE LEFT ON OUR YOUNG LIVES IS STILL TOO SPLENDIDLY CLEAR TO BE DIMMED.

RATHER, WE HAVE CAUSED THIS TO BE ERECTED WITH THE HOPE THAT ONCOMING GENERATIONS OF MILFORD PUPILS, DEPRIVED OF THE OPPORTUNITY OF KNOWING HER, MAY NEVERTHELESS BE REMINDED AS THEY PASS, THAT REAL AND ENDURING SUCCESS IN THIS EXPERIENCE WE CALL LIFE CONSISTS, NOT SO MUCH IN MERE ACHIEVEMENT, AS IN THE SORT OF UNFLINCHING DAY-BY-DAY GIVING OF SELF TO OTHERS THAT MISS SCOTT EXEMPLIFIED SO SHININGLY.

1864 — 1921

Uninhabited for more than 10 years, this old Milford house was once owned by Johanna Kumlehn and yielded a treasure trove valued at $8,500. This treasure was found by three Milford boys in 1953. Gold coins, old-style currency, and stock shares were found in a leather satchel at this house on Elm and Water Streets. The house was searched thoroughly the prior year, but only minimal treasure was found. Jack Holt, age 10; Fride Elmore, age 11; and Orville Chambers, age 12, turned over the cache to Mayor Robert Rinckhoff and police chief Joseph N. Wintersole. Two of the boys were pin boys at the Milford Bowling Lanes. This incident created so much interest that pictures of the boys and the house appeared in newspapers across the United States. (Courtesy of the GMAHS, Rinckhoff Collection.)

Two Milford boys are seen riding in a horse-drawn cart on Main Street, gathering refuse around 1933. Note the mare wearing fly protection, and she has her young foal at her side. The horse cart is stopped in front of the building that housed Dr. James C. Spence, Dr. Wesley P. Damerow, and Dr. James MacMillan.

This is a Halloween parade during the 1947 Milford Fall Festival. The judge certainly must have had a difficult time choosing the best costume winner. Note the creativity and variety of the homemade costumes. (Courtesy of the GMAHS, Rinckhoff Collection.)

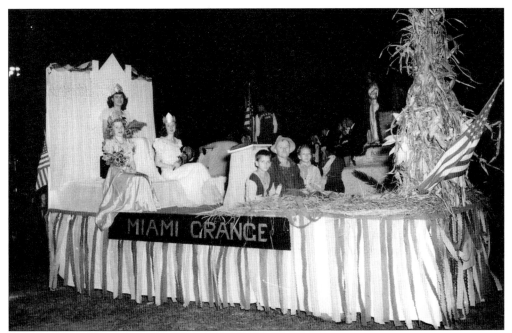

In the 1947 Milford Fall Festival parade, the Miami Grange float fetes royalty and promotes the local farming industry. The Milford area Grange was begun in 1913 with 74 names on the original charter. They adopted the name Miami Grange for their local lodge. (Courtesy of the GMAHS, Rinckhoff Collection.)

This presentation takes place in the gymnasium and auditorium that was added to the Milford Public School (Main) in 1928. It had a divided balcony, gymnasium floor, and stage. This area was renovated into classrooms in 1951. (Courtesy of the GMAHS, Rinckhoff Collection.)

Milford was the location of a liquor court. Local attorney Daniel Murphy was able to have the court located here. People had to come from as far as Dayton for hearings. Liquor court caused a lot of excitement. When the weather was good, the windows were opened and the locals gathered to listen to the proceedings. It is said that the money from these hearings was used to build 111 Main Street in 1922.

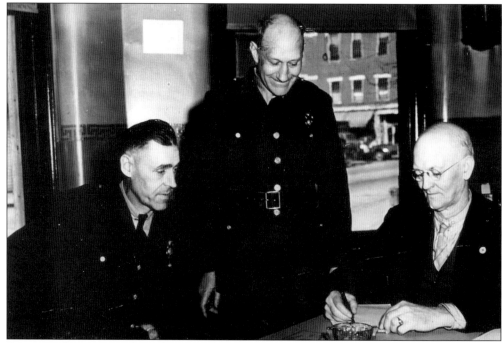

Signing a document and conducting official business in the Milford mayor's office from left to right are chief of police Joe Romohr (1942–1947), Charles (Chappie) Brewster, the well-known school patrolman, and Mayor Joseph Barrere (1940–1945).

When haying time arrived, all farm family members and nearby neighbors came together to get work done. This must have been a good year for hay, or it was a very large field to provide such a load for the hay wagon.

The Shumard Band Wagon is followed by veterans of the Civil War in the annual Decoration Day parade. The parade is taking place near where the shopping center on Lila Avenue is today. The bandwagon was probably painted by C. Fred Motzer, a manufacturer of carriages, buggies, and road and break carts from Milford.

Here at Epworth Heights is a group of young Milfordites enjoying a summer outing. Epworth Heights was a summer church camp near Loveland. Note the young woman on the left with the rifle and the large cannonball in the foreground. Among those included in the picture, Emmeline Gatch is in the front row holding the croquet mallet.

Sports played a very important role in the history of Milford. Here is the 1948 Milford Athletic Club baseball team, unbeaten in 17 straight games in the Buckeye League.

The 1918 Decoration Day celebration was held in front of Milford Main Public School. The man in this photograph is unidentified but appears to be in uniform and perhaps is in charge of the flag raising. In the photograph at right on the same bandstand is the mayor of Milford in 1918, Andrew Barton Applegate. Note the same people in the background of each picture.

The Milford lodge of the Knights of Pythias received its charter on May 23, 1890. There were 26 charter members. Charles Adams Jr., a baker, was a founder and charter member. He is the seventh man pictured from the left, seated at the table. The first meeting place was in the house on the site of the Odd Fellows hall at Main Street and Garfield Avenue.

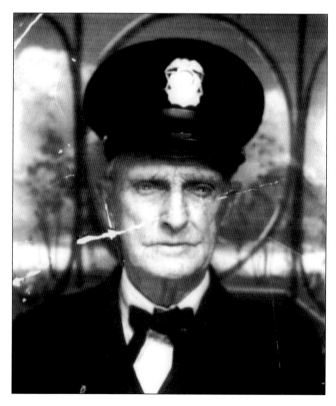

Joseph Pierson was the last marshal of Milford. He served from June 21, 1921, until 1943. He was born in August 1896 and resided at 24 Main Street next to the town hall. He died on August 12, 1943, and is buried in Greenlawn Cemetery.

Frank E. Brown, son of John Brown, stands in uniform at his service station across the street from the well-known Brown's Saloon and Boarding House. (Courtesy of Larry Curless.)

Above is a 1909 view of the first steel bridge going into Milford, as seen from the Pennsylvania Railroad station. Brown's Saloon and Boarding House can be seen on the left corner of the bridge. Note the streetcar tracks running to the right side of the bridge.

Pictured here is a Gatch family gathering at the 912 Forest Avenue home of Harry and Florence Gatch.

This postcard is thought to be of Harold Byrnes Gatch and his three children posing with two unidentified Native Americans.

Maj. James Bruce Wallace and his daughter Pauline sit on the front porch of their home on Wallace Avenue. Wallace was an extremely wealthy and successful businessman with many influential friends from around the country. Many of his well-known business transactions took place on Friday the 13th, one of which was a $1.25 million land purchase in downtown Cincinnati in 1902.

T. Paul Jordan stands dressed in his high school football gear in a photograph dated December 25, 1920. Jordan played football for Milford High School during the 1921–1922 school year.

These two scenes were taken during the flood of 1913. The above photograph shows the depth of the water as it rises on Water Street almost to Main Street at Elm Street. The house on the left is still standing. The occupants of this house were asked to evacuate but did not, thinking the water would recede. It did not, and they had to be rescued by boat. The rescuers landed on the roof of the two-story house and pulled them from the second floor. Below is a scene also on Water Street after the waters receded. Note the team and the wagon on the right. The driver was obviously helping displaced residents after the flood.

The Ohio Valley Egg Cooperative was run and managed by Lloyd Mullett from its inception in 1945 until the early 1970s, when he became the president of First Milford Savings. Mullett was a licensed federal and state inspector and egg-room manager before coming to the Milford plant. (Courtesy of Opal Mullett.)

The Ohio Valley Egg Cooperative bought the carbarn of the former Cincinnati and Columbus "Swing Line" Traction Company and began operations on July 1, 1945. Note the large doors that allowed traction cars to enter for repair. It represented egg producers from over 30 counties in southwestern Ohio, southeastern Indiana, and northern Kentucky. (Courtesy of Opal Mullett.)

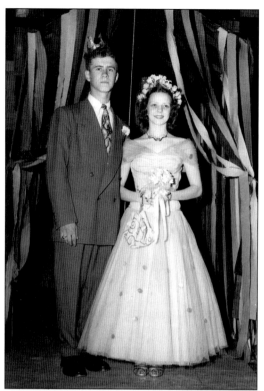

Reigning royalty of the 1948 Milford High School junior-senior prom are queen Virginia Conover and king Bruce Merker. Both of these Milford High School seniors were very active in school activities and events. In the 1948 *Droflim*, Merker's favorite song was listed as "Shanty Town."

Milford High School's Future Homemakers of America (FHA) sponsored the Sweetheart Dance every year. The 1949 queen candidates are, from left to right, Betty Jo Ledford, Anne Roudebush, Rosemarie Attinger, Edna Parker, and Mary Ann Bickel.

T. Paul Jordan plays disc jockey for the local children at a summer outing, possibly a Fourth of July celebration.

Grandpa Gatch and his dog Major are seen here.

The freshman class from Milford High School is seen here in 1915 on their botany field trip. The class was accompanied by teacher Julia Anna Christman.

Here is the Milford High School girls' basketball team with coach Dellos Worley in the 1920s.

Three

BUILDINGS
AND BUSINESSES

This picture, probably taken between 1894 and 1906, looks down from High Street on Garfield Avenue. To the left is Adams Bakery and across Main Street from it is the home of George Hickey, known as Hickey Corner, which later became the Milford National Bank. The building with the overhang is Finke Drug Store, later known as the Family Theatre. The National Hotel is on Water Street at the foot of Garfield Avenue. On the right, the J. B. Iuen Building, which later was known as the Ernst Building, can be seen. The streets are notably unpaved, while the sidewalks seem to be concrete. (Courtesy of Virginia Critchell.)

The water tower was constructed in 1901 as the first poured concrete standpipe in the United States and the largest structure of its kind in the world at the time. It was replaced in the 1950s and torn down in 1961 when it became a hazard. It took two weeks of battering with a frost ball and cutting with torches to demolish it.

In 1884, Charles Adams Jr., and his wife, Mary Belle Enyart Adams, remodeled the property at 32 Main Street and added a bakeshop with a brick oven, which was fired with wood. The bakery was open from 6:00 a.m. until 9:00 p.m. or 9:30 p.m. Charles began baking at 8:00 p.m. so the bakery goods were fresh for the morning trade. He drove the bakery wagon until 11:00 a.m.

Andrew Balzhiser's Ice Cream and Variety Store, located at 309 Main Street, was in operation from 1912 until 1924, when he retired. The store also handled meats, groceries, fruits, vegetables, and miscellaneous items. Note the brand names that are visible, including Ibold Cigars, Husman Potato Chips, Whites Ice Cream, and Vanilla Wafers. This was later the location of the Brass Rail Tavern.

Christian Ernst built the Milford Family Theatre in 1915 so that his family could enjoy Hollywood's films. Located at 208 Garfield Avenue behind the Milford National Bank, the theater maintained its own generator, as the electric service was not dependable. The first movie was shown on July 3, 1915, and Frank Booso was the first projector operator. The house seated 264, and admittance was 5¢ for children and 10¢ per adult.

Thomas M. Shumard was in the leather tack business. He used his second-floor room as headquarters for the Milford Cornet Band of which he was the director. The building was believed to have been located at Main and High Streets. Shumard is pictured on the right. In addition to his business in leather and his bandmaster's job, he served the village of Milford as mayor from 1878 to 1882.

Shumard, on the left, is showing a very dapper young man the value and precision of two buggy whips in his shop on Main Street in Milford. The tools of the trade are evident behind Shumard. The raw materials of the trade and the finished products surround him and his customer.

Located at 100 Main Street was the Steffens Jewelry shop. Here Henry Steffens conducted his watch, jewelry, and clock repair business and maintained a residence upstairs. The Steffens family was part of the German migration to the Midwest. His skills from the Old World greatly enhanced his business capabilities. He died a mysterious death after falling from the bridge in Old Milford.

This photograph is of the interior of the Milford National Bank, located on the corner of Main Street and Garfield Avenue. Several unidentified employees can be seen behind the teller cage. The sign attached to the teller's cage reads, "Member of the Ohio Banker's Association, 1909–1910."

George and Mary Randall are standing in front of their store located at 221 Garfield Avenue. The Randall's store specialized in fancy and staple groceries. Note the signs advertising Royal Coffee and Plantation Stogies.

E. B. Gatch's general store was located at 32 Water Street. Embly Barber Gatch (1851–1930) was also a postmaster and had the post office in his general store from July 24, 1897, until August 2, 1913. He operated the store until 1922, when he retired. His store was on the site of today's Masonic building.

The J. B. Iuen Building, located on the corner of Main Street and First Cross Street (Garfield Avenue), was built by the Milford Masonic Lodge in 1846 and was occupied by them in 1848. The Milford Seminary was located on the second floor and Iuen's store was on the first floor. The building was sold to Iuen in 1887 or 1888. The colorful history of this building includes being a home to the Milford National Bank, the Citizens National Bank, Stumph's Pharmacy, Johnson Pharmacy, Gatch Insurance Agency, and the Korner Barber Shop. It was known as the J. B. Iuen Building until 1915, when it was purchased by Christian Ernst.

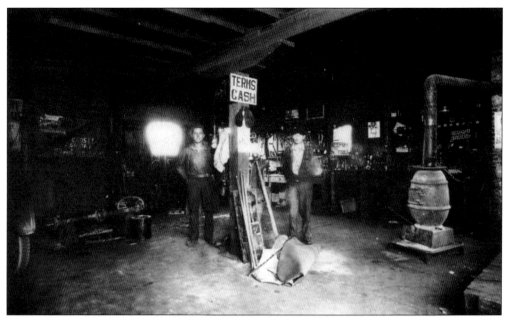

Gas station business flourished in Milford in the mid-1900s after World War II, when automobiles became the main mode of transportation in the nation. Pictured is the interior of Eigher's Pure Oil Service Station around 1930. Located at Main Street and Wallace Avenue, this station offered a shop to provide any manner of work on the vehicle required to keep it in good running order. Note the sign "Terms cash."

The large stone building was built in 1840 by John Kugler as a corn warehouse. The smaller building was a distillery with the Inderrieden Blacksmithing and Horse Shoeing Shop in between. All of Kugler's businesses, with the exception of the mill, ceased operation when he died on January 5, 1868.

The new Jesuit novitiate was built in 1927 to accommodate 600 men. The Reverend J. F. Neeman, Society of Jesus (Jesuits), was the first clergyman in charge of the institution. Crowe and Schulte were the architects, and the Leopold-Farrel Company did the construction. The above photograph was taken on October 16, 1926. The photograph below is a group photograph of the novitiate construction crew and was taken on November 23, 1926. This construction project provided employment for hundreds of local laborers.

Milford Waterworks superintendent and engineer John G. Erion started work on March 2, 1904. The original system, which he commanded, was a simple purifications plant using steam-powered pumps to supply water to its customers on the distribution system. The water was notorious for its flinty hardness. It acquired meteoric fame in the 1940s as a folk remedy for nephritis. People came from Cincinnati and far distances, bearing jugs and bottles to collect water from the plant. Some water was even shipped out of the state via railroad. There was no charge for the water that was shipped.

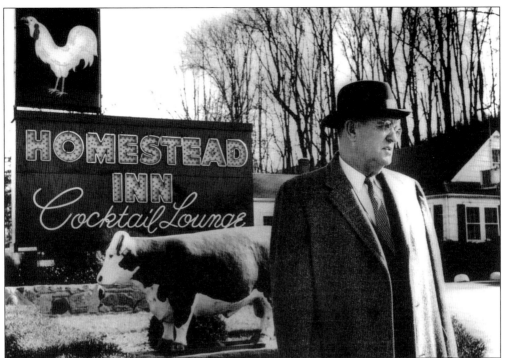

The Homestead Inn at 730 Lila Avenue was a favorite of Milford residents for years. Many families enjoyed a traditional chicken dinner on Sunday afternoons. Shown is Roscoe Peterson, proprietor from 1953 to 1963. The original business was started by Emma Balzhiser. The bull seen in the background is currently located at Shaw farm in Milford.

William Irwin of the Rock House is credited with bringing golf to the area in 1898, when he returned from Scotland with a few golf clubs. Enthusiasm for the game grew and an 18-hole golf course was developed on the Woodward farm near the East Fork of the Little Miami River. In December 1946, the original Terrace Park Country Club pictured above was almost completely destroyed by fire.

The historic Gatch home in Milford was built by the Reverend Philip Gatch for his son Thomas. The stone of the 30-inch walls is not native but similar to that imported around 1800 for a bridge across the Little Miami River. The land where this house is located is part of John Nancarrow's survey number 1748. The house still stands within 40 feet of Interstate 275. Through the efforts of several historical societies, the house, springhouse, and large barns, all long-famous landmarks, have been spared from the ravages of progress. A member of the original Gatch family occupied this house until it was purchased by a local businessman.

The Milford Public School was built in 1912 and 1913 on the site of the old Union School. The bricks from the old school were auctioned to W. F. Motsinger, who used them to construct the building at Elm and Main Streets. Dr. C. J. Spence, president of the board of education, put numerous items in the cornerstone of the building "as per custom since the building of Solomon's Temple."

Every fall, as harvest season approached, workers gathered and traveled from farm to farm. The above photograph is of Dieckmeyer workers, who owned equipment for harvesting these crops. They came and worked the farmland at harvest time. This photograph illustrates equipment at the beginning of the steam era. (Courtesy of Bob and Gail Laudeman.)

The above picture was on a calendar given away by B. F. Kruthaup Jr. of his general store on Route 28 in Mulberry. The calendar was dated 1911. The advertisement on the top of the picture read as follows: "Compliments of B. F. Kruthaup, Jr., General Merchandise, Hardware, Vehicles, Implements, Fertilizer, Fencing, Stoves, Etc. Highest prices paid for butter, eggs, poultry, calves, etc." The building still stands today.

The Milford Public Library building was built about 1835 by John Kugler. He used the first floor as a warehouse and the second floor as a public meeting hall. Dr. Richard C. Belt's family began the first Milford library and declared in his will that this building would be managed by trustees as long as there is a library in any part of it. If there is not a library there, the building will be inherited by Terrace Park Episcopal Church.

This is the Johnson Funeral home around 1930 at 526 Main Street. Later owners of the funeral home were John Craver, Donald Hookum, and Edward Riggs. This was also the site of Milford's third school, a small brick structure, probably built in the 1830s.

For generations, Milford residents have enjoyed a trip to Rouster's Apple House. One of the patrons' favorite apples is the Krispy, developed here in Clermont County. The picture at right is of the original fireplace, which has remained the same for decades.

P. W. Guilday is seen here inside his store. The photograph shows the merchandise of the period. Some of the brand names on the products are Baker's Sweet Chocolate and Prince Albert Tobacco. Shelves of canned goods and bulk products line the walls. An advertisement for "Cream cakes" for 5¢ can be seen in the display case window.

The power plant for the Cincinnati and Columbus Traction Company was located in West Milford, or Montauk. The *Brill Magazine* wrote that the powerhouse had a capacity of 1,000 kilowatts transmitted at 16,500 volts with 650 volts in the trolley wire. In 1920, 17 adjacent communities were receiving power from this plant.

William D. Saunders sits in the office of Milford Realty Company at 124 Main Street in Milford.

Chester J. Mundhenk, engineer at the Milford Public School, is in the boiler room.

Blanketed with 17 inches of snow, the corner of Main Street and Garfield Avenue was a desolate intersection in the winter of 1917. Two sets of horse-drawn plows can been seen dragging the snow removal equipment. John Lotz's barbershop, shown on the corner behind the team of four

horses, became the Milford Building Loan and Savings Company. Across Garfield Avenue is the former Adams Bakery, which became the Ginabea Shoppe, and in back of the barbershop on Garfield Avenue stands the old Swing Line interurban depot.

Milford elementary school students participate in a folk dance at an assembly in the old Milford High School gymnasium before its renovation around 1948.

This drinking fountain is located in the Milford Main School and remains there today. It is constructed of Rookwood pottery and was donated to the school by the Mother's Club in 1925.

Four

TRAILS, RAILS, AND TROLLEYS

Two unidentified children and a footman wait patiently in their buggy in front of 431 Garfield Avenue, the Hayward Gatch home. Note the lap robe tucked in snuggly around their legs.

The coming of the Cincinnati, Milford and Loveland Traction Company made possible the introduction of electric power and lighting for the town of Milford. The traction company created its own electric generating plant in Montauk, and it was able to be the low bidder for the first village contract to erect streetlights in the lower part of town. Below is a group photograph of several traction company workers.

Here is the front and back cover of an original timetable for the Cincinnati, Milford and Loveland Traction Company. The date reads, "in effect May 16, 1913." Local businesses purchased advertising space on the timetable.

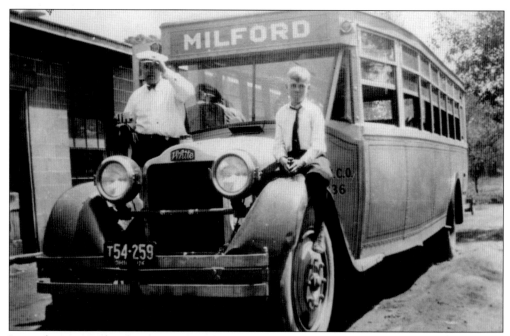

Interurban motor bus lines contributed to the doom of the electric interurban traction lines running to and through Milford. One was the Blue Bus Line, operating from a downtown terminal in Cincinnati. At the Milford end of the line was a terminal located in a concrete block structure built by Andy Conover near the intersection of Main Street and Lila Avenue.

The Little Miami Railroad depot at Milford was leased by the Pennsylvania Railroad in 1869. Commuter trains ran from Loveland, Branch Hill, Miamiville, Camp Dennison, Milford, and Terrace Park to other depots and finally to Cincinnati. It was from this depot that president-elect Abraham Lincoln stepped from his railroad car and spoke to the people of Milford on his inaugural journey to Washington, D.C., on February 13, 1861. (Courtesy of the GMAHS, Rinckhoff Collection.)

Railroad sites such as these were common in the Milford area. The locomotive seen above could have been part of the Little Miami Railroad line. This line later became part of the Pennsylvania Railroad. However, accidents like the one seen below caused disruption in the local rail service.

This photograph looks west down Main Street in the early 1900s. Note the horse-and-buggy form of transportation, early street lighting, and the dirt roads. The sidewalks, however, appear to be made of concrete.

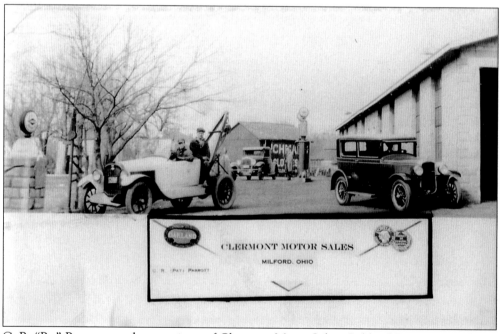

C. R. "Pat" Parrott was the proprietor of Clermont Motor Sales, Oakland Pontiac in Milford. Note the early tow truck with pulley attached.

In 1922, Walter and Erwin Rauscher opened the Rauscher Brothers Service Station at 200 Mill Street. Magee Adams wrote that this was the first gas and oil station that bore any resemblance to what was common after World War II. It was a full-fledged service station with Firestone tires, a repair shop, and bulk-oil business. The Rauscher Brothers remained in business until December 1936, when it became Kenneth Conklin's Mobilgas Station.

The charming wooden bridge of 1818 gave way to a steel bridge. In 1893, the new bridge was begun. Hamilton County paid $40,000 and Clermont County paid $10,000 for the new span that was 280 feet long, had a 24-foot-wide roadway, and had six-foot-wide sidewalks. The bridge was often called the "Iron Bridge." Below, the bridge can be seen as it was being demolished in 1924. Before it was replaced with another steel bridge, river crossing was possible by a pontoon foot bridge.

A vintage panel truck is advertising the Scott Brothers Company. These advertisements include Milford Mills and Mil-Cler-O Flour manufactured by the Scott Brothers Company. The truck was manufactured by the U.S. Motor Truck Company. The panel delivery trucks followed horse and buggy for delivery of merchandise.

An unidentified man and the family dog pose on the running board of the family vehicle in front of a restaurant bearing the sign "Chicken Dinner." This establishment was known as the Homestead Inn for many years.

In the *Chimes of Normandy* program of 1907, presented by the Milford Opera Club, was an advertisement that read, "C. Fred Motzer, manufacturer of carriages, buggies, road and break carts. Painting and trimming a specialty. Milford, Ohio." Motzer had a talent of considerable value. He painted and trimmed the circus wagons and carriages for the John Robinson Circus that wintered in Terrace Park. Motzer was born in Germany in 1848, and he and his wife, Caroline Hausserman, were the parents of seven children, including three boys and four girls. Note behind the children the wagon that has been painted to read "Euclid Military Band."

Car 116 of the Cincinnati, Milford and Loveland Traction Company sits at the wye in Milford, waiting for the eastbound car. The conductor is Henry Foster, and the motorman is Mr. Blackburn. Note the signal box and telephone on the pole.

On March 5, 1927, the *Cincinnati Commercial Tribune* reported, "Ross V. Hickey, undertaker of Milford, escaped death yesterday when an inbound Milford car of the Cincinnati Street Railway Company jumped the tracks and crashed through the front end of his home on Main Avenue, Milford. It came to a stop only inches from the couch where he was napping."

Here are two street scenes of Main Street in Milford. The above scene is from the late 1930s. Note the savings and loan and hardware store on the right and the Johnson drugstore and Kroger store on the left side of the street. The scene below is from the early 1950s. Main Street traffic was still quite heavy, as can be witnessed by bumper-to-bumper parking.

1905

These two photographs show construction of the Cincinnati and Columbus "Swing Line" Traction Company bridge at Milford in December 1905. A crane fell 40 feet, pulling some men with it. One worker was drowned when he was pinned under the water. He had just started on the job a week before. This was just one of a series of accidents that plagued the completion of this bridge. Note the men in the picture below, one of whom is standing out in the water at the site of the accident.

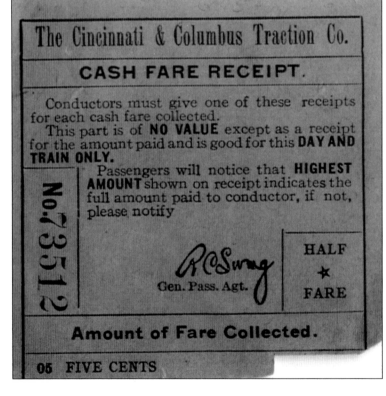

The Cincinnati & Columbus Traction Co.

CASH FARE RECEIPT.

Conductors must give one of these receipts for each cash fare collected.

This part is of **NO VALUE** except as a receipt for the amount paid and is good for this **DAY AND TRAIN ONLY.**

No. 73512

Passengers will notice that **HIGHEST AMOUNT** shown on receipt indicates the full amount paid to conductor, if not, please notify

R C Swng
Gen. Pass. Agt.

HALF
★
FARE

Amount of Fare Collected.

05 FIVE CENTS

The photograph above shows a busy day at the Perintown station of the Cincinnati and Columbus Traction Company, where passengers are ready to board the traction car. At left is a cash fare receipt for the line, also called the Swing Line. Note the receipt is signed by R. C. Swing.

This pontoon bridge was built by Ross Hickey using oil-drum floats equipped with handrails and electric lights. Crossing was something of an adventure when high water set the river lapping at the oil drums. This was the only way pedestrians could cross the Little Miami River while the new steel bridge was being built in 1924. It was located behind Rauscher Brothers Service Station.

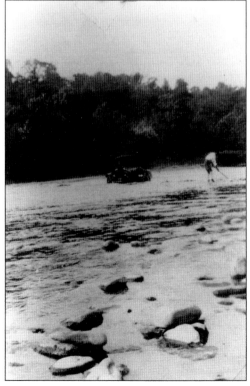

While the new bridge was being built, men raised the river bed with rocks at the ford located at the foot of Elm Street so that the automobiles could drive across without stalling, although some still did not make it. Note the car in the water, the very latest in style and speed.

Here is a rare photographic view of east Milford before the creation of Riverside Park. The photograph was taken from the Hamilton County side. Notice the horse and buggy traveling on Montauk Pike, which is now Route 126.

Around Milford streets, this was a common site. During the hot summer months, the horse-drawn water wagon was used to keep the dust down on the dirt roads.

Members of the Milford Volunteer Fire Department are standing proudly in front of the fire engines in the mid-1940s. The fire department was located in the old town hall on Main Street. It still owns the pumper on the right, and it appears in local parades.

Ken Eigher Sr. of Ken and Sons Service Station poses at home with a 1927 Dodge.

A Bell Telephone crew posed for this group shot on Main Street across from the funeral home. Note the solid rubber tires and the acetylene lights that were typical during the second decade of the 20th century.

While out for an afternoon ride, three dapper Milford residents stop for a chat along the roadside. From left to right are William Williams, Harold Byrnes Gatch, and Henry Owens.

This 1929 Ford Model A was purchased new from Shumard Ford by Robert Brilmayer, a 1919 Milford High School graduate. It was later owned by Bill Helmsdorfer, a 1964 Milford High School graduate. Harold Curless, father of Larry, who graduated from Milford High School in 1963, and Gary, who graduated from Milford High School in 1970, purchased the car from Helmsdorfer. It is now owned by Gary, who lives in Michigan. This vehicle has never left the hands of a Milford High School graduate.

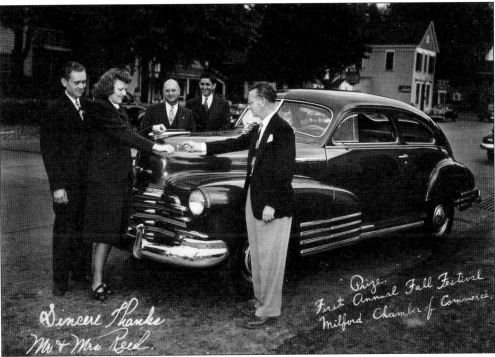

The grand-prize winners of the automobile given away at Milford's first Fall Festival, Mr. and Mrs. Reed, are receiving the keys for the car from James Franklin, owner of the Millcroft Inn.

Both of these photographs show the traffic and congestion that was a frequent site on Main Street in Milford. The above scene is from the early 1940s and appears to be a celebration of some sort. The Western Auto store can be seen on the left. The people on the right are standing under the overhang of Adams Bakery. The scene below is from the early 1950s. Shoppers are frequenting Bokman Drugs, the Ben Franklin Store, Rosenzweig's Department Store, and the bank.

The Owensville, Milford, Norwood Bus Line operated from January 1, 1926, until October 25, 1930. It was owned by the Cincinnati Street Railway Coach and was known as Route N. The first type of bus used by the line was a Model T Ford.

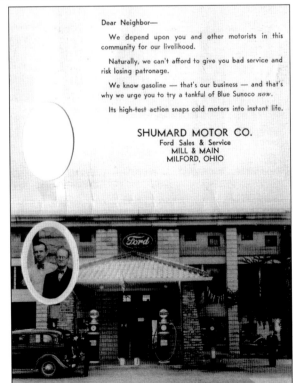

Dear Neighbor—

We depend upon you and other motorists in this community for our livelihood.

Naturally, we can't afford to give you bad service and risk losing patronage.

We know gasoline — that's our business — and that's why we urge you to try a tankful of Blue Sunoco *now*.

Its high-test action snaps cold motors into instant life.

SHUMARD MOTOR CO.
Ford Sales & Service
MILL & MAIN
MILFORD, OHIO

The Shumard Motor Company was owned by Victor Shumard Sr. and was ably assisted by his son Victor Shumard Jr. This advertisement for their business is from the 1930s. This building still remains in the Shumard family.

This picture was snapped in 1915 on Park Road. Barney Vancamp (left), Mr. Braunson, and Henry Pinkvoss (right) pose with this Overland Sports Back, the finest of its time. Note that the car is a right-hand drive.

Pictured here is the Pennsylvania Railroad bridge underpass over Wooster Pike around 1939. The train is heading toward Terrace Park, and through the underpass is Wes Rahn's Barbeque. The Ford "Woody" on the left is most likely a 1937 model.

Five

PROMONT, PATTISONS, PROSPERITY

At Promont in Milford, Velma Grace Hodges, daughter of Henry A. Hodges, and Henderson Grover Hightower of Covington were united in marriage by the Reverend C. N. Van Pelt of the Madisonville Methodist Church in October 1911. The ceremony was performed in one of the large parlors of the old Victorian home. It was garlanded with smilax and decked with flowers. Velma, who was given in marriage by her father, wore a gown of Irish linen tissue, heavily embroidered and trimmed with Irish crochet and Valencia lace. The wedding dinner was served in the spacious and elegant dining room.

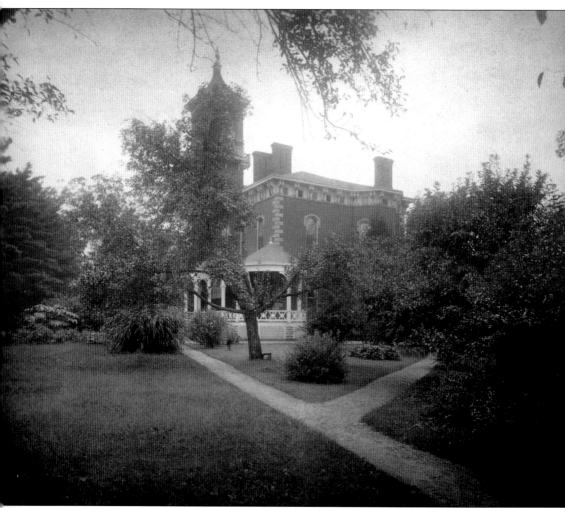

This photograph, taken in 1905, shows Promont, which stands on property that belonged to Milford's very first settler, Francis McCormick. This Victorian Italianate mansion, listed on the National Register of Historic Places, was built between 1865 and 1867 by the Megrue family. It was named Promont by William Williams because of its location high above the city of Milford. It was also the home of John M. Pattison, from 1879 to 1906. Pattison was the 43rd governor of Ohio. After passing through the hands of several owners, the house was left to the Greater Milford Area Historical Society upon the death of its last owner, James Kirgan, in 1983.

The veranda at Promont was often the site of summer entertaining. The back parlor window opened directly onto the veranda, which allowed guests to step directly outside. In the above 1903 photograph is Aletheia Pattison, daughter of the governor. Note the custom-designed railing illustrating an Asian influence, which was very popular during this period. Pictured below is the veranda and its furnishings as it typically appeared at this time, with fresh flowers and floral print pillows. (Courtesy of Suzanne Pattison Zesch.)

Promont is pictured here in 1897. Pattison family members identified in this photograph are, from left to right, Ernestine E., cousin Helen Hamilton, Aletheia E., Buckeye the dog, Aletheia W., John M., and John Williams Pattison. Note the striped awnings and the tin roof construction. The shutters in the windows are the same ones that are in the house today. (Courtesy of Suzanne Pattison Zesch.)

Here is the imposing carriage house prior to its demolition in the mid-1980s. This structure was approximately the same size as the main residence, about 40 feet by 40 feet. It was a two-story brick stable with eight stalls, a carriage room, a loft, and plastered quarters for the coachmen.

Ernestine E. and Aletheia E. Pattison, daughters of Gov. John M. and Aletheia W. Pattison, sit in front of the fireplace in one of Promont's bedrooms. Aletheia E. is in the rocking chair reading and Ernestine appears to be making a journal entry at her desk. This bedroom is now the Leonard L. Harding Jr. Library of the Greater Milford Area Historical Society. (Courtesy of Suzanne Pattison Zesch.)

The Pattison children, Aletheia E., John W., and Ernestine E., pose for the photographer in a studio in downtown Cincinnati. The girls are wearing matching dresses and John's jacket and vest are made of brown velvet. (Courtesy of Suzanne Pattison Zesch.)

Aletheia E. Pattison smiles after a tumble from her "wheel" on the grounds of Promont. The long drives and pavement around the fountain provided ample area for riding and playing outdoors. (Courtesy of Suzanne Pattison Zesch.)

Gov. John M. Pattison and Buckeye the dog sit by the front porch enjoying a beautiful day. Buckeye, part St. Bernard and part Newfoundland, was just one of many pets and various animals kept on the property by the Pattisons. (Courtesy of Suzanne Pattison Zesch).

Old Elizabeth Nieyers, the cook at Promont, was famous for her coconut cake and Dutch apple cake. (Courtesy of Suzanne Pattison Zesch.)

Jim Dennison Jr., was the houseman and coachman for the Pattisons. His father was the postmaster in Milford from 1857 to 1861. Dennison was a descendent of Ohio's governor William Dennison. (Courtesy of Suzanne Pattison Zesch.)

Gov. John M. Pattison is standing in the statehouse yard in Columbus in 1905. This photograph was taken while he attended the Democratic Governor's Convention. A native of Owensville, he was elected 43rd governor of Ohio. He was also president of the Union Central Life Insurance Company during its period of greatest expansion. He married Aletheia Williams on December 10, 1879. They had four children: Aletheia E., Ernestine E., John W., and Donald. His first wife, Aletheia, died in March 1891, and Pattison then married her sister Anne in 1893. His term as governor was cut short after a diagnosis of Bright's disease. He died in June 1906 at his beloved home, Promont. (Courtesy of Suzanne Pattison Zesch.)

Cousin Louise Williams rides one of the ponies during a visit to Promont. At one time, the Pattisons owned more than 23 ponies. Note that cousin Louise is quite the young lady, riding sidesaddle. (Courtesy of Suzanne Pattison Zesch.)

Ernestine E. (left) is pictured here with the family dog Rex, and Aletheia E. is with another family dog, possibly Carlo, below the veranda at Promont. Pets were a very important aspect in the lives of the Pattisons. (Courtesy of Suzanne Pattison Zesch.)

The Pattison children, Ernestine E., Aletheia E., and John W., with one of their favorite ponies, Jenny Jones, camp out on the grounds at Promont. Jenny Jones was known to have climbed the stairs and entered the house at Promont. (Courtesy of Suzanne Pattison Zesch.)

Three of the many Pattison ponies, Jenny Jones, Spritely, and Cottontail, graze on the grounds at Promont. (Courtesy of Suzanne Pattison Zesch.)

Ernestine E. poses for a Christmas portrait around 1899. Note the extremely elegant holiday dress. (Courtesy of Suzanne Pattison Zesch.)

Aletheia E. is seen here in a formal portrait at a studio in downtown Cincinnati around 1900. (Courtesy of Suzanne Pattison Zesch.)

A pouting John W. Pattison is sitting on a tree stump near the front steps to Promont on a dreary winter day. (Courtesy of Suzanne Pattison Zesch.)

This photograph of Aletheia E. Pattison sitting outdoors, possibly on the grounds at Promont, illustrates the lush foliage at that time. (Courtesy of Suzanne Pattison Zesch.)

Gov. John M. Pattison and his son John W. are seen here in Columbus around 1905. John W. had a passion for flying but was unable to serve for the United States military due to a lengthy illness. He traveled to Europe and eventually recovered. He then flew with the Polish Air Force in World War I. He received the 109th pilot's license issued by the United States and was a member of the Early Birds. The Early Birds was an organization whose membership was limited to those who could provide evidence that they had soloed in any aerial craft prior to December 17, 1916. Only 599 people were awarded memberships. (Courtesy of Suzanne Pattison Zesch.)

This is part of the back spiral staircase in Promont, which ascends from the basement to the fourth-floor tower. Note the intricate architectural design in the wood.

The back parlor of Promont is seen here from the front parlor. The windows in the rooms went all the way to the floor and were used as doors to step outside onto the veranda or any one of the many balconettes. The Pattison settee in the foreground is presently on display by the Greater Milford Area Historical Society in the parlor.

One of Milford's best-known industrial ventures was the Milford Manufacturing Company, the carpet-sweeper factory. It opened in 1888 at 220 Mill Street. It occupied the entire building and employed about a dozen people. It manufactured suction sweepers, with the most well known being the Victoria Sweeper. At right is the advertising card for the Victoria Sweeper.

The Victoria Sweeper.

THE MILFORD MANUFACTURING CO.

MILFORD OHIO.

The Milford Cornet Band, with E. C. Shumard as leader, was the successor to the original band organized by his father, Thomas M. Shumard, about 1865. Formerly it was a military band managed by A. Squires, who then had a music store in Cincinnati. Thomas had become a member of that band after being mustered out of the army following the close of the Civil War. His son, E. C., took it over in 1903 and reorganized the group. This picture was taken on the stage of Milford Town Hall in 1913. Note the elaborate window treatments and the detailed scenery. From left to right, the musicians are Dick Stump (partially missing), E. Cramer, Arthur Christopher, Milay Cooper, John Dennison, Walter Elliott, Frank Cutter, E. C., Tad Eigher, Vic Kuhn, John Stephens, Harry Shroeder, Charles Elstun, Joe Lotz, Hall Bieler, and ? Bingham.

The baseball team in this photograph was named the Perintown Players. A few of the members are identified. From left to right are (first row) Ike Friend, Ed Ragland, Joe Friend, Louis Laudeman, Charles Chalfant, George Davis, ? Bickel, and Bill Laudeman; (second row) ? Krouse, Brose Leaf, and Lyman Barrow. An unidentified boy mascot is sitting in front with all the bats, masks, and equipment

William Taylor Irwin purchased the land formerly known as Kugler's Woods (later the Jesuit novitiate). After renaming the property the Ripples, Irwin's estate boasted a staff of six maids, a cook, a butler, a nurse, four farmers, three gardeners, a coachman (later a chauffeur), and a houseboy. They lavishly entertained around the pool and across the lawn. Guests included Cincinnati families like the Tafts and Proctors, and parties had over 400 people.

The second-annual reunion of the Gatch family was held on the site of the first Gatch schoolhouse in the beautiful grove of Maj. James Bruce Wallace on October 1, 1892. The day of the reunion was one of ideal sunshine and happily enjoyed by members of the family who traveled from as far as Maryland to the golden gate of sunny California and from the northern lakes to faraway South America. The photograph below is the Gatch family reunion two years later in 1894.

The high school was organized separately from the grades in 1880, and three years were required for graduation. It was not until 1906 that the high school required four years for graduation. This photograph shows the Milford High School classes of 1883, 1884, and 1885. The class of 1883 graduated three women: Sallie Scott, Emeline Gatch, and Mattie Christopher.

The Milford High School basketball team is seen here in 1914. From left to right are (first row) Ehret Adams (captain), Charles Whitenack, Wright Erion, and James Roudebush; (second row) Charles Cook, Charles Daughters, coach D. B. Clark, Hubert Holzlin, and Marcellus Chandler. Clark also served as superintendent of Milford schools.

The Mulberry Seminary, located at the village New Salisbury between Milford and Goshen, was an ambitious project formed by an association of citizens, in September 1864, who believed that an academy could be permanently maintained in Miami Township. In the rush to build an attractive educational edifice during that winter, costs soon exceeded the capital stock of $30,000, and the school struggled during its 12 years of existence. The tall Gothic, gabled two-story brick structure with a bell tower remained a landmark on the road to Goshen. It was torn down for its bricks and timber in 1915.

Milford High School class of 1913 graduates are standing on the front lawn of the new Milford Main School (above). From left to right are (first row) Jesse Shumard, Goldie Hutchinson, Ruth Goodwin, and Elsie Davis; (second row) Sam Bateman, Mary Dew, Ethel Bateman, and Bryon Terwillegar. In the photograph below, the graduates are attired in their caps and gowns, ready for graduation.

The Milford Cornet Band, led by E. C. Shumard, marches on Main Street. Note the traction line tracks in the dirt.

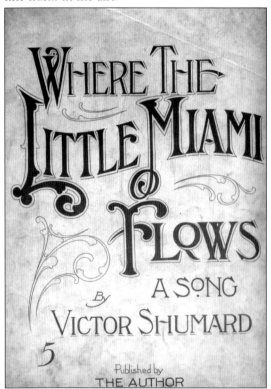

This is the sheet music for "Where the Little Miami Flows," a song written and published by Victor Shumard in 1913 in Milford. The chorus reads, "Wind on your way, by night and by day, where the beautiful, beautiful blue grass grows. There's no spot half so dear as the valley right here, where the Little Miami flows."

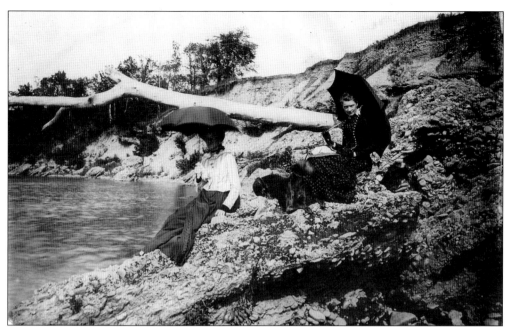

These ladies and their dog have chosen a lovely spot on the bank of the Little Miami River near Milford for their summer picnic. In 1900, no young lady would be seen wearing anything but proper dress, including parasols, gloves, and hats, no matter how warm the day. In the photograph below, these three ladies have found a similar spot to rest and relax.

Dr. Richard C. Belt was reared on his family's home farm in Williamsburg Township and studied medicine under Dr. A. C. Moore of Amelia. He completed his courses at the Ohio Medical College in Cincinnati, graduating in 1873. He located his medical offices in Milford in 1874. For more than 50 years, Belt practiced medicine here.

In 1834, Asbury P. Gatch was born in Miami Township in Clermont County to George and Sarah Gatch. He was married to Etta Elizabeth Hopper. Asbury served as captain of Company L, Ninth Regiment, Ohio Volunteer Cavalry, and among his many credentials was his service to Gen. William T. Sherman and his march to the sea during the Civil War. Seen with Asbury is his grandson Asbury Leonce Odebrecht.

Katherine Molloy and her elementary class are pictured here around 1908. Molloy was the mother of James B. Kirgan, former owner and resident of Promont.

Kirgan was an owner and resident of Promont from 1951 until 1983. He bequeathed the Promont house to the Greater Milford Area Historical Society.

These two photographs were part of the collection of Maj. James Bruce Wallace, a longtime Milford resident. The individuals in these photographs are unidentified, yet they depict the luxury and leisure time enjoyed by the residents of Milford during the Gilded Age. Note the woman with the black eye on the back of the sled.

I wish I had a girl in
Milford, Ohio

This postcard, dated 1914, was addressed to Eva Holland of Milford and sent by John Reynolds. It reads, "I wish I had a girl in Milford, Ohio."

ACROSS AMERICA, PEOPLE ARE DISCOVERING SOMETHING WONDERFUL. *THEIR HERITAGE.*

Arcadia Publishing is the leading local history publisher in the United States. With more than 3,000 titles in print and hundreds of new titles released every year, Arcadia has extensive specialized experience chronicling the history of communities and celebrating America's hidden stories, bringing to life the people, places, and events from the past. To discover the history of other communities across the nation, please visit:

www.arcadiapublishing.com

Customized search tools allow you to find regional history books about the town where you grew up, the cities where your friends and family live, the town where your parents met, or even that retirement spot you've been dreaming about.

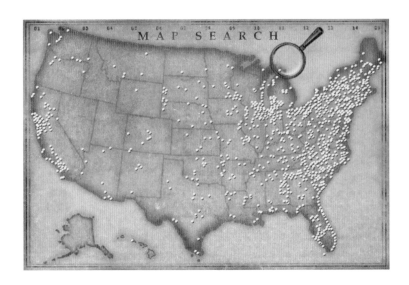